NIELSEN'S
Fairy Tale Illustrations
in Full Color

KAY NIELSEN

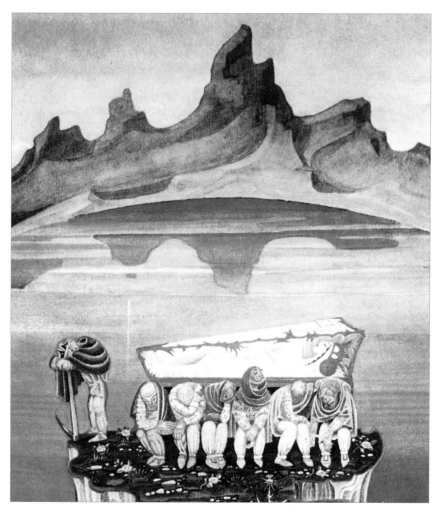

DOVER PUBLICATIONS, INC.
Mineola, New York

Bibliographical Note

This Dover edition, first published in 2006, is an original compilation of illustrations from the following works: *East of the Sun and West of the Moon: Old Tales from the North,* published by G. H. Doran Company, New York, 1922 [all 25 full-color plates; the illustration that faced page 72 now appears on the front cover of the Dover edition, rather than the book interior]; *In Powder and Crinoline,* published by Hodder & Stoughton, London, 1913 [all 24 full-color plates have been used]; *Hansel and Gretel and Other Stories by the Brothers Grimm,* published by Hodder & Stoughton, London, 1925 [5 full-color plates have been used]; and *Fairy Tales by Hans Andersen,* published by G. H. Doran Company, New York, 1924 [5 full-color plates have been used]. A Publisher's Note has been prepared specially for the present edition.

Library of Congress Cataloging-in-Publication Data

Nielsen, Kay Rasmus, 1886–1957.
 Nielsen's fairy tale illustrations in full color / Kay Nielsen.
 p. cm.
 Compilation of illustrations from four children's books.
 ISBN-13: 978-0-486-44902-9
 ISBN-10: 0-486-44902-5
 1. Nielsen, Kay Rasmus, 1886–1957. 2. Fairy tales—illustrations. I. Title.
 II. Title: Fairy tale illustrations in full color.

NC986.5.N53A4 2006
741.6'4092—dc22

2006042307

Manufactured in the United States by Courier Corporation
44902504
www.doverpublications.com

PUBLISHER'S NOTE

Kay Nielsen was one of the most accomplished artists of the Golden Age of children's book illustration, which spanned the late nineteenth to early twentieth centuries. Illustrations for children's books were colored by hand in the early 1800s, but by the late nineteenth century, artwork by renowned artists such as Nielsen, Walter Crane, Arthur Rackham, and Edmund Dulac was being reproduced to stunning effect by four-color process book printing. Expensive illustrated gift books were ideal formats for these prolific artists, who frequently turned to the rich world of fairy tales for their subject matter.

Kay Nielsen was born in Copenhagen, Denmark, in 1886 to actor parents. Kay (pronounced "kye") began drawing as a child and moved to Paris in his late teens to study art. His watercolors for the gift books *In Powder and Crinoline* and *East of the Sun and West of the Moon* were exhibited in 1913 and 1915, respectively, in a London gallery; and his illustrations for *The Fairy Tales of Hans Andersen* were on view in London in 1924. After a stint designing stage productions for the Danish National Theater, Kay Nielsen married Ulla Pless-Schmidt. In 1936, Nielsen moved to Los Angeles (his wife didn't join him there until the beginning of World War II), where he continued designing for the stage and began working in the movies. Most notably, he helped design the "Ave Maria" and "Night on Bald Mountain" sequences for the Walt Disney film *Fantasia*. During the postwar period, changing tastes and an interest in more realistic artistic expression limited the opportunities for artists such as Nielsen, whose stock-in-trade was fantasy. Thereafter, Nielsen devoted himself to producing murals for local schools in Los Angeles, as well as the Wong Chapel of the First Congregationalist Church; in fact, when he died in 1957, mourners gathered there for his funeral service.

The Japanese printmaker Hiroshige (1797–1858) had a significant impact on Western art and on the work of such illustrators as Nielsen. This influence is especially noticeable in his stylized treatment of waves as demonstrated by Plates 4, 5, and 42; the bridge scene in Plate 25 also evokes Japanese woodblock prints. Kay Nielsen frequently used intricate patterns to "build" his characters, as in Plates 7, 12, 17, 18, 19, and 24. The artist often emphasized the costumes at the expense of the storybook characters, mounting tiny, sparingly detailed heads atop voluminous garments. Yet there also are stark, expressive, heroic faces (Plates 2, 9, 12, 28), and romantic intimations (Plates 2, 30, 38, 69). It is also noteworthy that in his later works (the Grimm and Andersen collections), Nielsen abandoned the intricate Beardsley-influenced line rendering in favor of broad, more fleshed-out depictions of characters and their surroundings.

The fifty-nine color plates in this edition include all twenty-five plates from *East of the Sun and West of the Moon: Old Tales from the North* (G. H. Doran Company, New York, 1922); all twenty-four plates from *In Powder and Crinoline* (Hodder & Stoughton, London, 1913); five plates from *Hansel and Gretel and Other Stories by the Brothers Grimm* (Hodder & Stoughton, London, 1925); and five plates from *Fairy Tales by Hans Andersen* (G. H. Doran Company, New York, 1924).

LIST OF PLATES

Front Cover *Then he coaxed her down and took her home* ("The Lassie and Her Godmother" [East of the Sun and West of the Moon: Old Tales from the North, G. H. Doran Company, New York, 1922])

Note: Titles of the books in which the illustration plates originally appeared, as well as plate captions and titles of the stories containing the plates, are given below.

East of the Sun and West of the Moon: Old Tales from the North
[G. H. Doran Company, New York, 1922]

1 *"Well, mind and hold tight by my shaggy coat, and then there's nothing to fear," said the Bear, so she rode a long, long way* ("East of the Sun and West of the Moon")

2 *"Tell me the way, then," she said, "and I'll search you out"* ("East of the Sun and West of the Moon")

3 *And then she lay in a little green patch in the midst of the gloomy thick wood* ("East of the Sun and West of the Moon")

4 *The North Wind goes over the sea* ("East of the Sun and West of the Moon")

5 *And flitted away as far as they could from the Castle that lay East of the Sun and West of the Moon* ("East of the Sun and West of the Moon")

6 *The Lad in the Bear's skin, and the King of Arabia's daughter* ("The Blue Belt")

7 *She saw the Lindworm for the first time as he came in and stood by her side* ("The Blue Belt")

8 *She could not help setting the door a little ajar, just to peep in, when—Pop! Out flew the Moon* ("The Lassie and Her Godmother")

9 *He too saw the image in the water; but he looked up at once, and became aware of the lovely Lassie who sate there up in the tree* ("The Lassie and Her Godmother")

10 *"Here are your children; now you shall have them again. I am the Virgin Mary"* ("The Lassie and Her Godmother")

11 *"You'll come to three Princesses, whom you will see standing in the earth up to their necks, with only their heads out"* ("The Three Princesses of Whiteland")

12 *So the man gave him a pair of snowshoes* ("The Three Princesses of Whiteland")

13 *The King went into the Castle, and at first his Queen didn't know him, he was so wan and thin, through wandering so far and being so woeful* ("The Three Princesses of Whiteland")

14 *The six brothers riding out to woo* ("The Giant Who Had No Heart in His Body")

15 *"On that island stands a church; in that church is a well; in that well swims a duck"* ("The Giant Who Had No Heart in His Body")

16 *He took a long, long farewell of the Princess, and when he got out of the Giant's door, there stood the Wolf waiting for him* ("The Giant Who Had No Heart in His Body")

17 *When he had walked a day or so, a strange man met him. "Whither away?" asked the man* ("The Widow's Son")

18 *But still the Horse begged him to look behind him* ("The Widow's Son")

19 *And this time she whisked off the wig; and there lay the lad, so lovely, and white and red, just as the Princess had seen him in the morning sun* ("The Widow's Son")

20 *The Lad in the Battle* ("The Widow's Son")

21 *Just as they bent down to take the rose a big dense snowdrift came and carried them away* ("The Three Princesses in the Blue Mountain")

22 *The Troll was quite willing, and before long he fell asleep and began snoring* ("The Three Princesses in the Blue Mountain")

23 *As soon as they tugged at the rope, the Captain and the Lieutenant pulled up the Princesses, the one after the other* ("The Three Princesses in the Blue Mountain")

24 *No sooner had he whistled than he heard a whizzing and a whirring from all quarters, and such a large flock of birds swept down that they blackened all the field in which they settled* ("The Three Princesses in the Blue Mountain")

IN POWDER AND CRINOLINE
[Hodder & Stoughton, London, 1913]

25 *Princess Diaphanie walking in the garden* ("Minon-Minette")

26 *"Ah, Princess!—Surely you are not running away from me"* ("Minon-Minette")

27 *He had to take to his bed for a week* ("Minon-Minette")

28 *And there on a throne all covered with black sat the Iron King* ("Minon-Minette")

29 *Princess Minon-Minette rides out in the world to find Prince Souci* ("Minon-Minette")

30 *Prince Souci and Princess Minon-Minette on the fan* ("Minon-Minette")

31 *"List, ah, list to the zephyr in the grove!*
 Where beneath the happy boughs
 Flora builds her summerhouse:
 Whist! Ah, whist! While the cushat tells his love." ("Felicia, or The Pot of Pinks")

32 *Felicia thereupon stepped forth, and terrified though she was, saluted the Queen respectfully: with so graceful a curtsey* ("Felicia, or The Pot of Pinks")

33 *Felicia listening to the hen's story* ("Felicia, or The Pot of Pinks")

34 *"This good Fairy placed her own baby in a cradle of roses and gave command to the zephyrs to carry him to the tower"* ("Felicia, or The Pot of Pinks")

35 *The Princesses on the way to the dance* ("The Twelve Dancing Princesses")

36 *When the cock crowed* ("The Twelve Dancing Princesses")

37 *She stopped as if to speak to him; then, altering her mind, went on her way* ("The Twelve Dancing Princesses")

38 *"Don't drink!" cried out the little Princess, springing to her feet; "I would rather marry a gardener!"* ("The Twelve Dancing Princesses")

39 *"I have had such a terrible dream," she declared. ". . . . a pretty bird swooped down, snatched it from my hands and flew away with it"* ("Rosanie or The Inconstant Prince")

40 *A look—a kiss—and he was gone* ("Rosanie or The Inconstant Prince")

41 *Each was delicious in her different way; and, for the life of him, he could not make up his mind* ("Rosanie or The Inconstant Prince")

42 *The ship headed about and sped over the depths of the sea* ("The Man Who Never Laughed")

43 *And the mirror told him that his were indeed the withered face and form* ("The Man Who Never Laughed")

44 *"It's about the Princess, my daughter. She has not smiled for a whole year"* ("John and the Ghosts")

45 *"Your soul!—My soul!" they kept saying in hollow tones, according as they won or lost* ("John and the Ghosts")

46 *Bismarck discovering the soldier* ("The Czarina's Violet")

47 *The old woman who knew the story* ("The Czarina's Violet")

48 *Czarina's Archery* ("The Czarina's Violet")

HANSEL AND GRETEL AND OTHER STORIES BY THE BROTHERS GRIMM
[Hodder & Stoughton, London, 1925]

49 *They saw that the cottage was made of bread and cakes* ("Hansel and Gretel")

50 *They wrote her name upon it, in golden letters, and that she was a king's daughter* ("Snowdrop")

51 *She managed to slip out so slyly that the King did not see where she was gone* ("Catskin")

52 *The little man dashed his right foot so deep into the floor that he was forced to lay hold of it with both hands to pull it out* ("Rumpelstiltskin")

53 *Then the dragon made a dart at the hunter, but he swung his sword round and cut off three of the beast's heads* ("The Two Brothers")

FAIRY TALES BY HANS ANDERSEN
[G. H. Doran Company, New York, 1924]

54 *"Oh, very badly indeed," she replied. "I have scarcely closed my eyes the whole night through. I do not know what was in my bed"* ("The Real Princess")

55 *The draught of air caught the dancer, and she flew like a sylph just into the stove to the tin soldier* ("The Hardy Tin Soldier")

56 *That was a pleasure voyage. Sometimes the forest was thick and dark, sometimes like a glorious garden full of sunlight and flowers* ("Ole Luk-Oie")

57 *And when I get back and am tired, and rest in the wood, then I hear the Nightingale sing* ("The Nightingale")

58 *"We'll mount so high that they can't catch us, and quite at the top there's a hole that leads out into the wide world"* ("The Shepherdess and the Chimney-Sweeper")

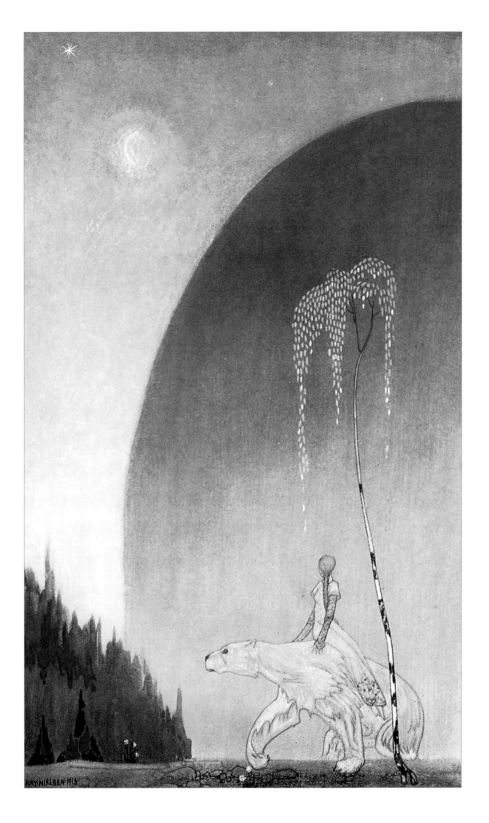

PLATE 1

"Well, mind and hold tight by my shaggy coat,
and then there's nothing to fear," said the Bear,
so she rode a long, long way
("East of the Sun and West of the Moon")

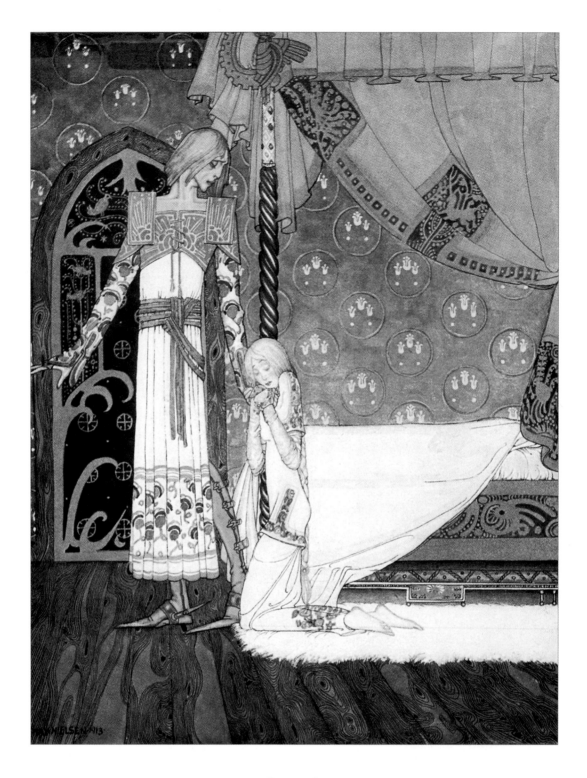

PLATE 2

*"Tell me the way, then," she said, "and I'll
search you out"*
("East of the Sun and West of the Moon")

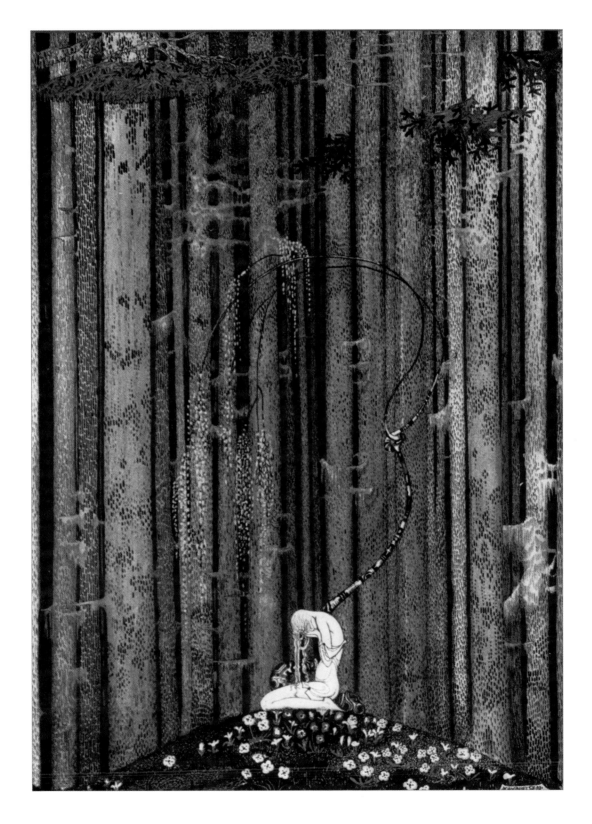

PLATE 3

And then she lay in a little green patch in the midst
of the gloomy thick wood
("East of the Sun and West of the Moon")

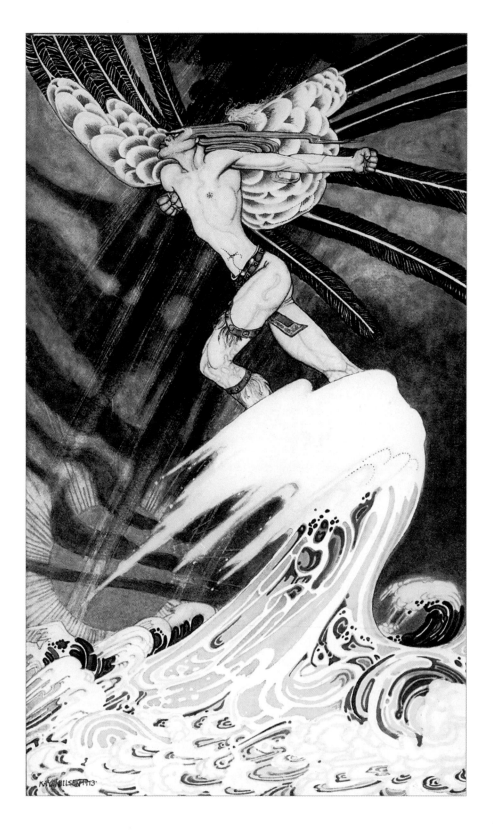

PLATE 4

The North Wind goes over the sea
("East of the Sun and West of the Moon")

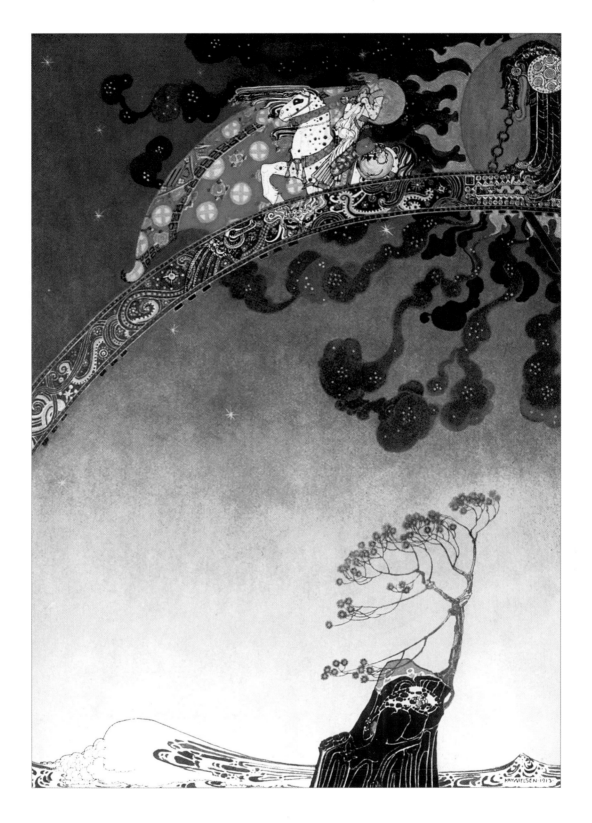

PLATE 5

*And flitted away as far as they could from the Castle
that lay East of the Sun and West of the Moon*
("East of the Sun and West of the Moon")

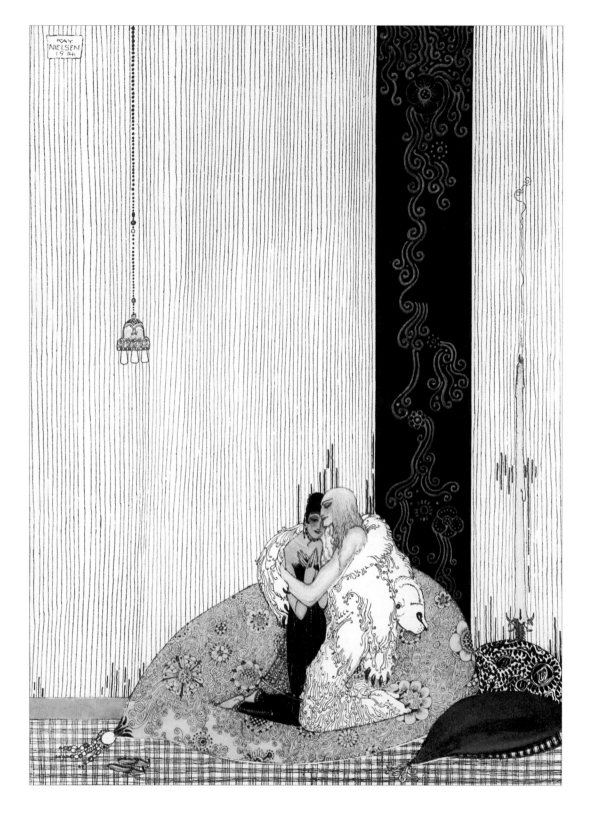

PLATE 6

The Lad in the Bear's skin, and the King of Arabia's daughter
("The Blue Belt")

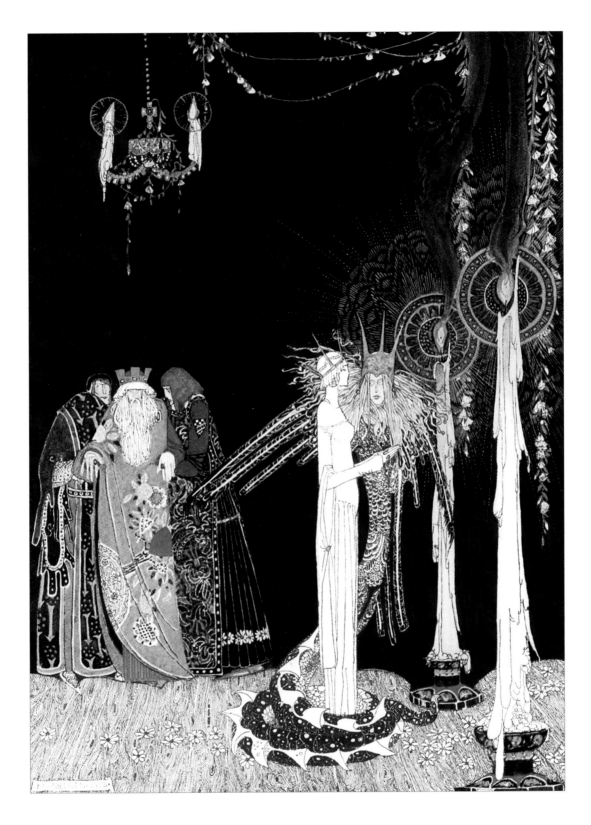

PLATE 7

She saw the Lindworm for the first time as he came in
and stood by her side
("The Blue Belt")

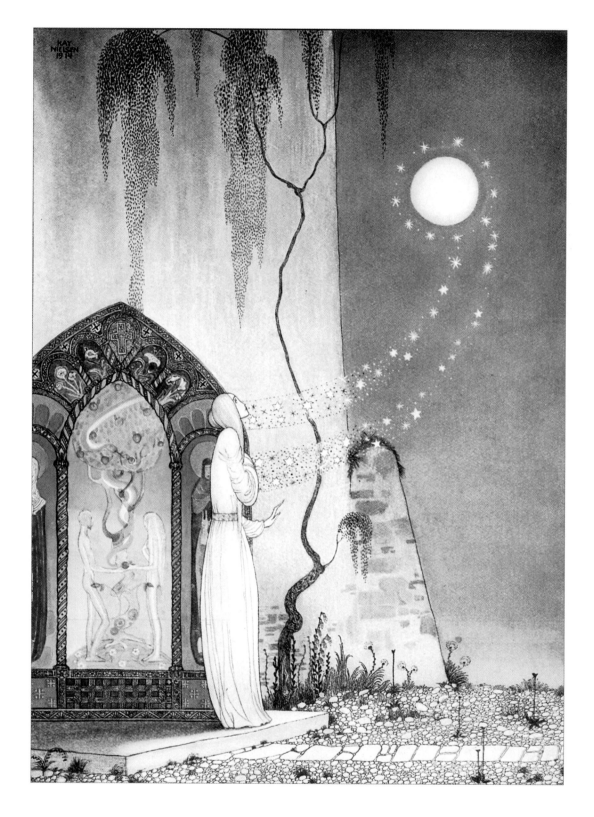

PLATE 8

She could not help setting the door a little ajar, just to peep in,
when—Pop! Out flew the Moon
("The Lassie and Her Godmother")

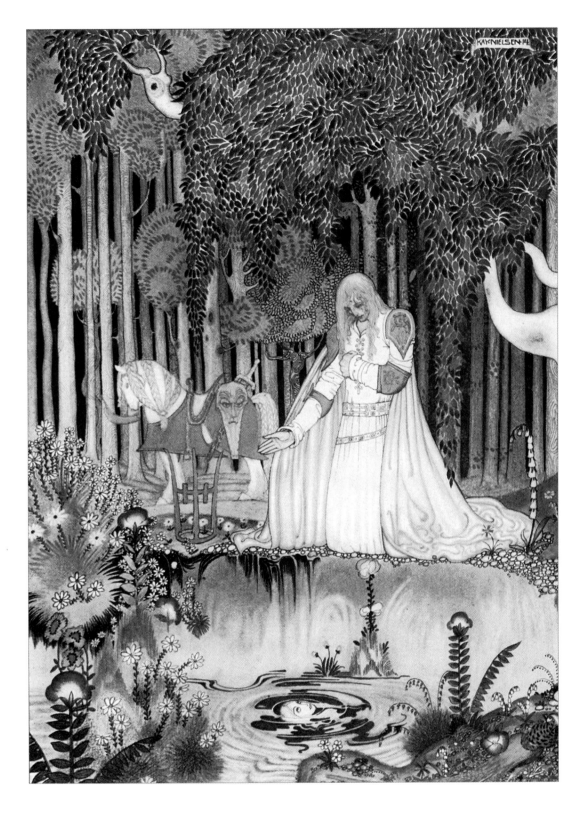

PLATE 9

He too saw the image in the water; but he looked up at once,
and became aware of the lovely Lassie
who sate there up in the tree
("The Lassie and Her Godmother")

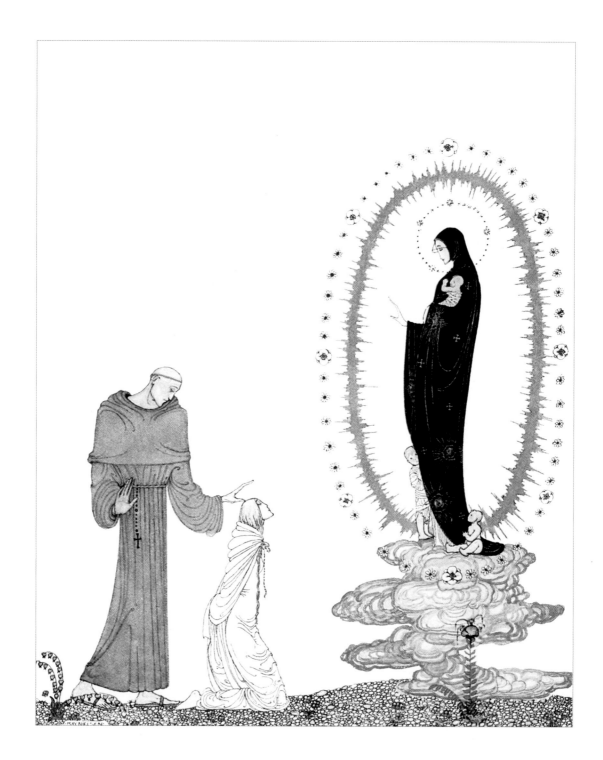

PLATE 10

"Here are your children; now you shall have them again.
I am the Virgin Mary"
("The Lassie and Her Godmother")

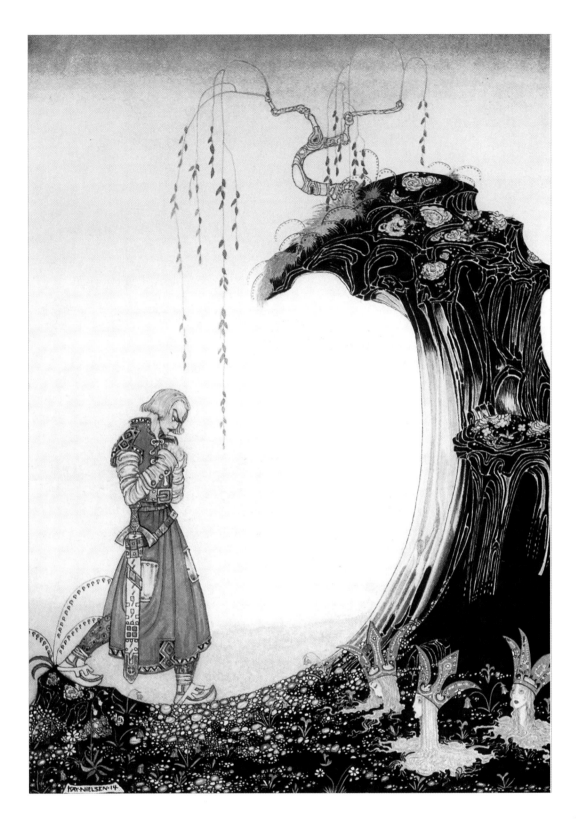

PLATE 11

"You'll come to three Princesses, whom you will see standing
in the earth up to their necks, with only their heads out"
("The Three Princesses of Whiteland")

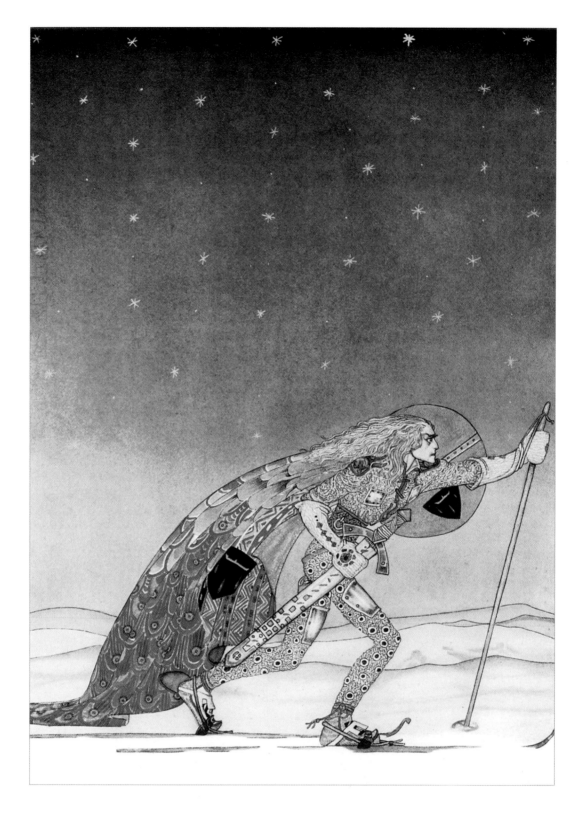

PLATE 12

So the man gave him a pair of snowshoes
("The Three Princesses of Whiteland")

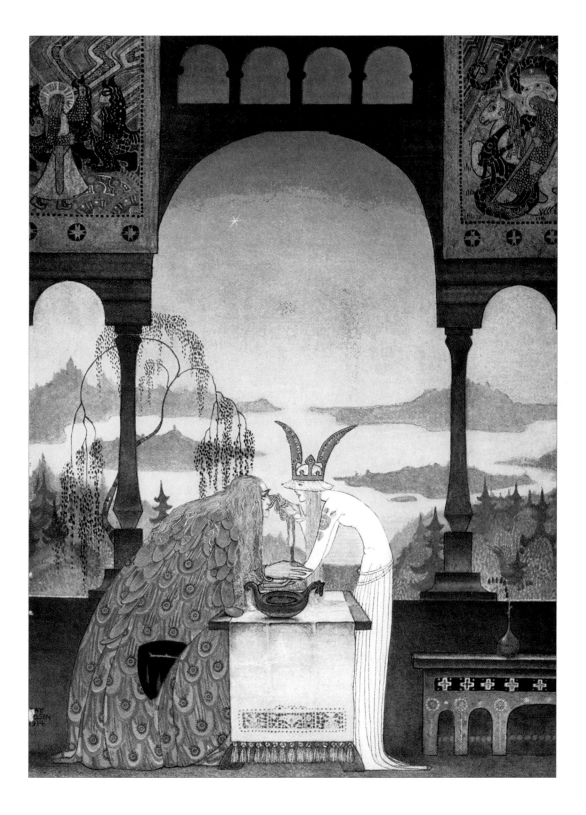

PLATE 13

The King went into the Castle, and at first his Queen
didn't know him, he was so wan and thin,
through wandering so far and being so woeful
("The Three Princesses of Whiteland")

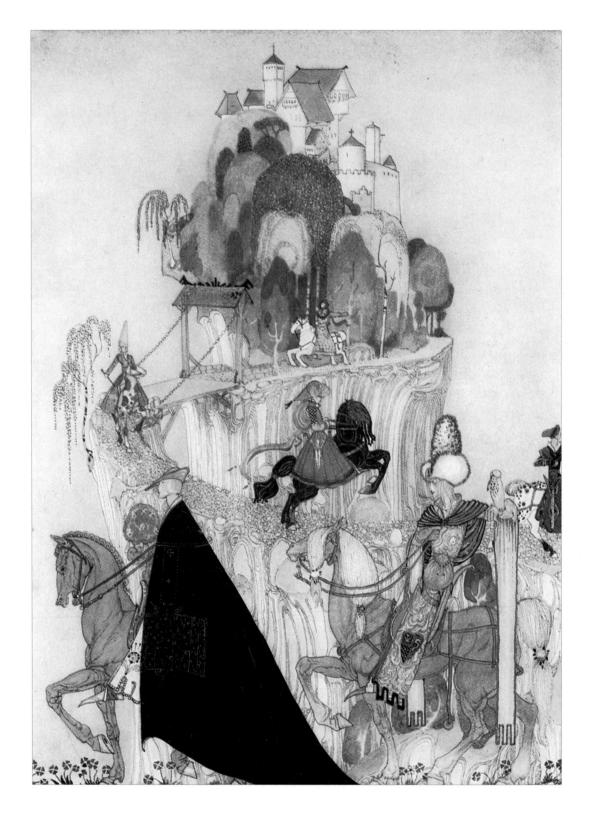

PLATE 14

The six brothers riding out to woo
("The Giant Who Had No Heart in His Body")

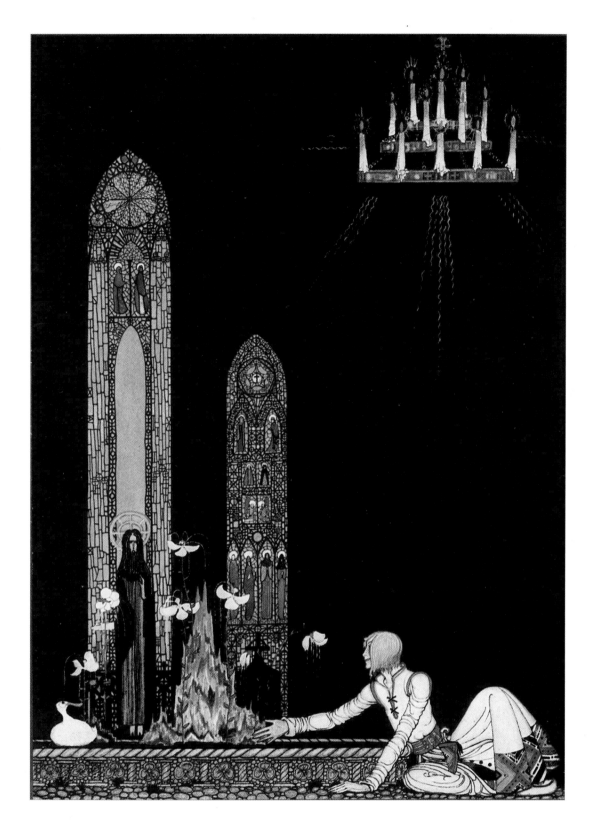

PLATE 15

"On that island stands a church; in that church is a well;
in that well swims a duck"
("The Giant Who Had No Heart in His Body")

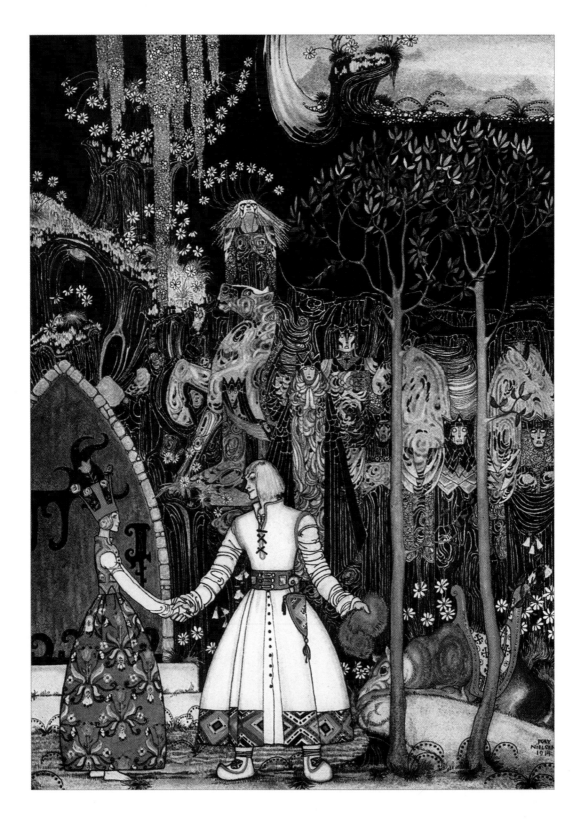

PLATE 16

He took a long, long farewell of the Princess,
and when he got out of the Giant's door,
there stood the Wolf waiting for him
("The Giant Who Had No Heart in His Body")

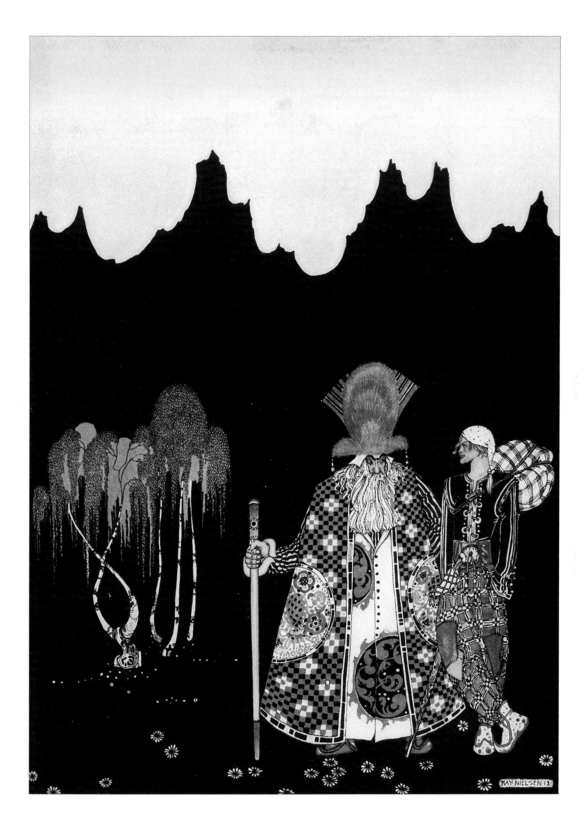

PLATE 17

When he had walked a day or so, a strange man met him.
"Whither away?" asked the man
("The Widow's Son")

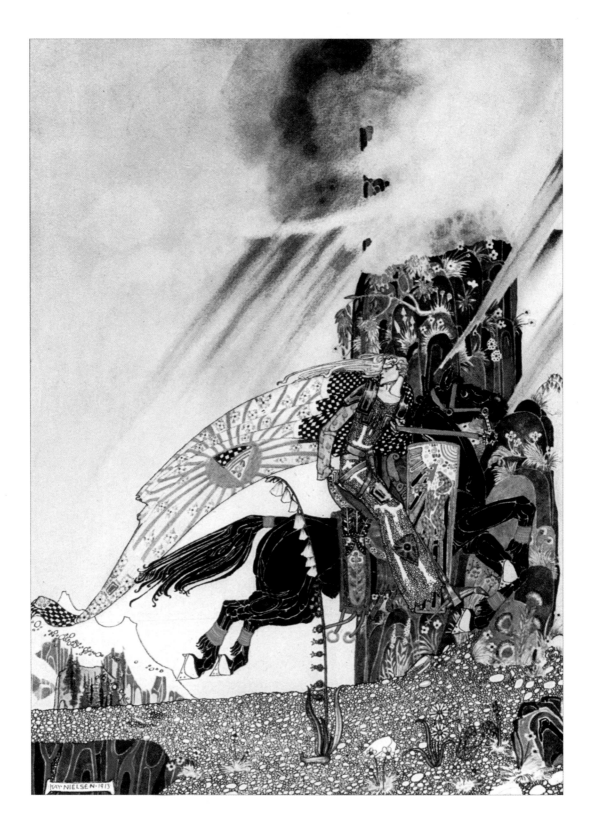

PLATE 18

But still the Horse begged him to look behind him
("The Widow's Son")

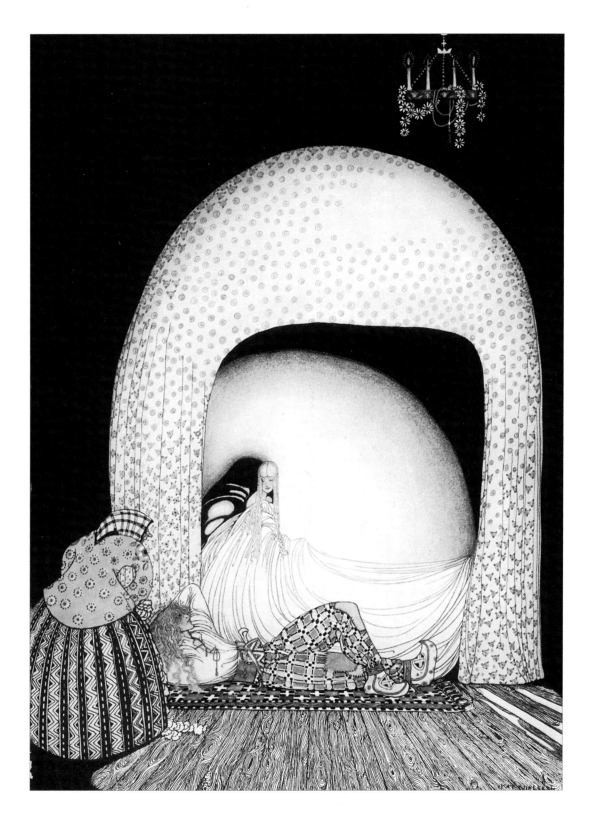

PLATE 19

*And this time she whisked off the wig; and there lay the lad,
so lovely, and white and red, just as the Princess
had seen him in the morning sun*
("The Widow's Son")

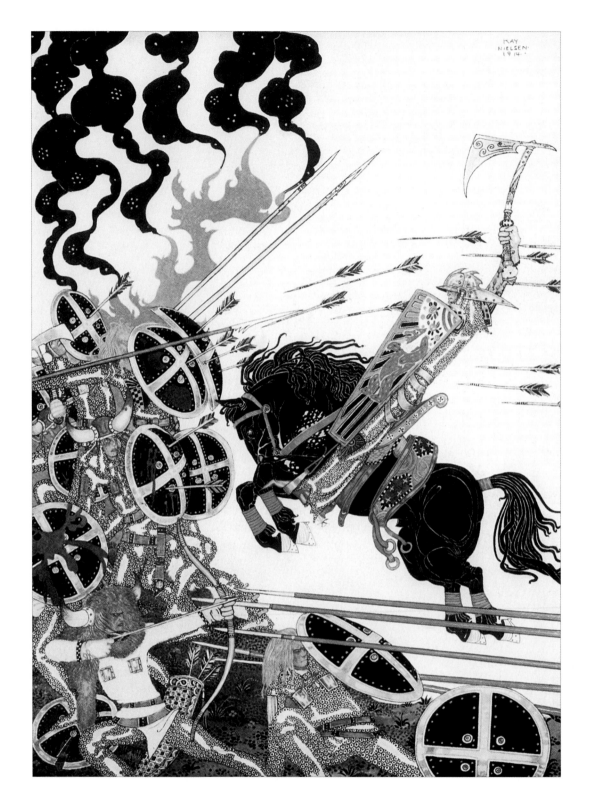

PLATE 20

The Lad in the Battle
("The Widow's Son")

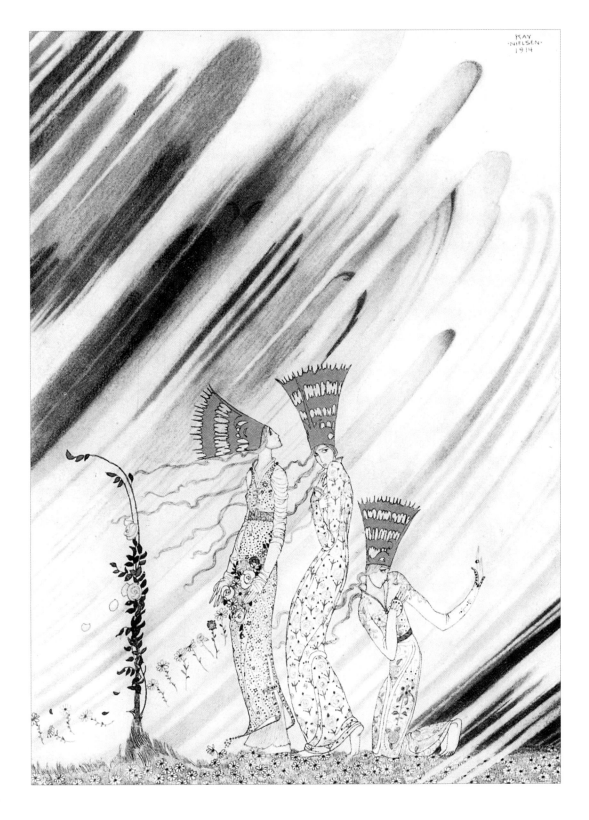

PLATE 21

Just as they bent down to take the rose
a big dense snowdrift came
and carried them away
("The Three Princesses in the Blue Mountain")

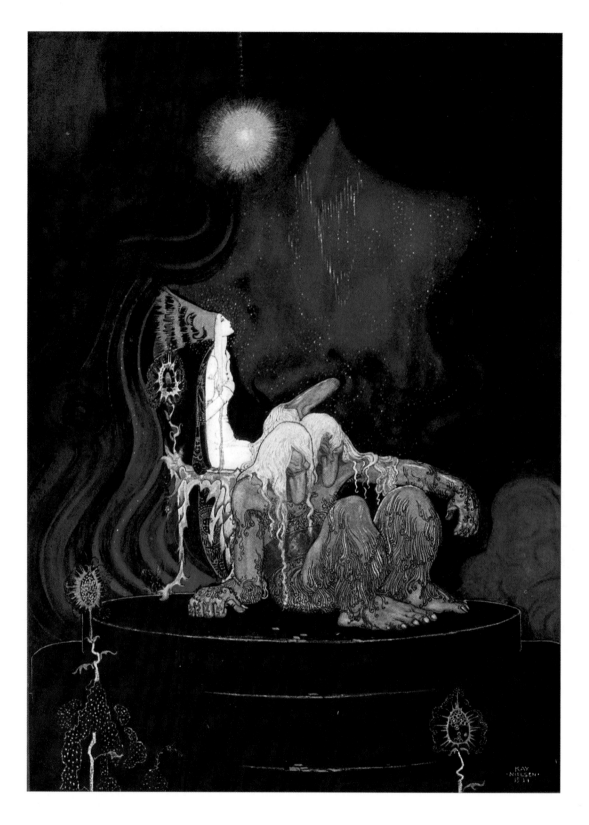

PLATE 22

*The Troll was quite willing, and before long he fell asleep
and began snoring*
("The Three Princesses in the Blue Mountain")

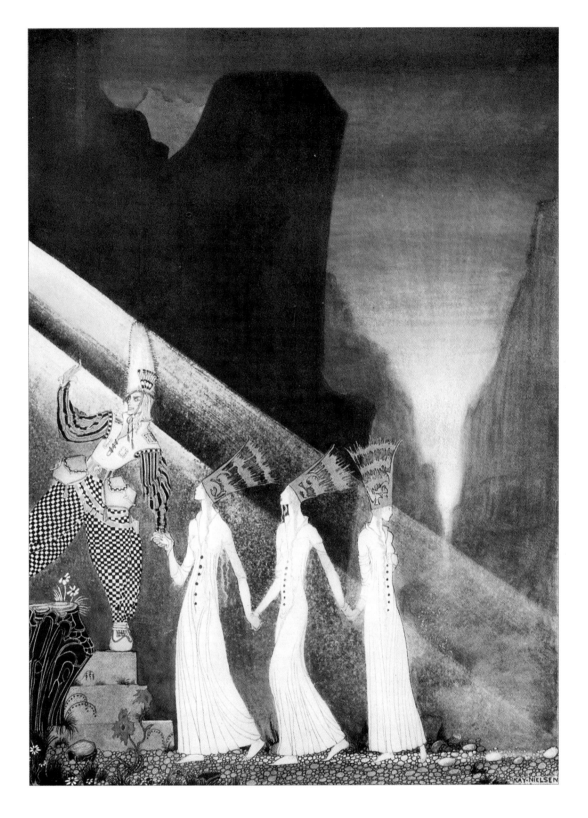

PLATE 23

*As soon as they tugged at the rope, the Captain and the Lieutenant
pulled up the Princesses, the one after the other*
("The Three Princesses in the Blue Mountain")

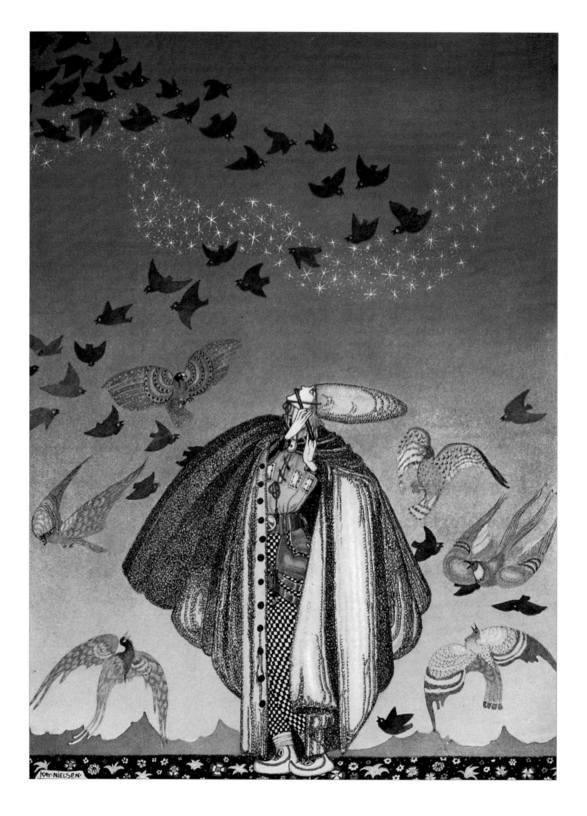

PLATE 24

*No sooner had he whistled than he heard a whizzing and a whirring
from all quarters, and such a large flock of birds swept down
that they blackened all the field in which they settled*
("The Three Princesses in the Blue Mountain")

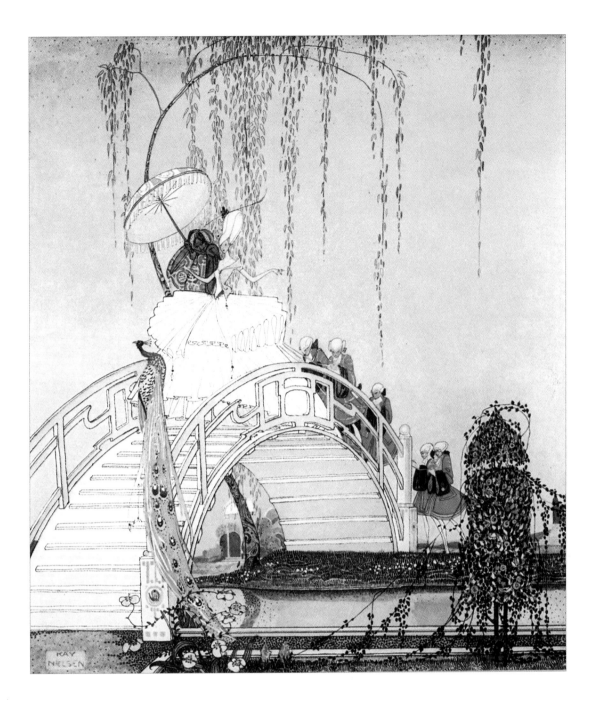

PLATE 25

Princess Diaphanie walking in the garden
("Minon-Minette")

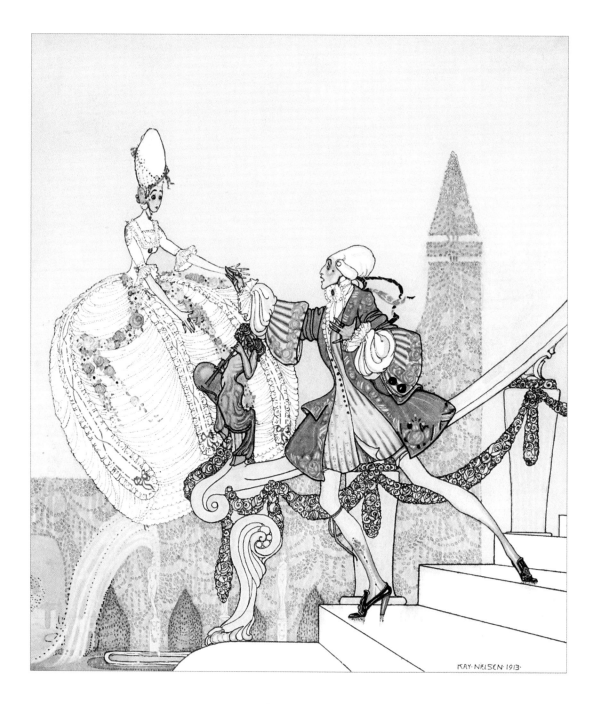

PLATE 26

"Ah, Princess!—Surely you are not running away from me"
("Minon-Minette")

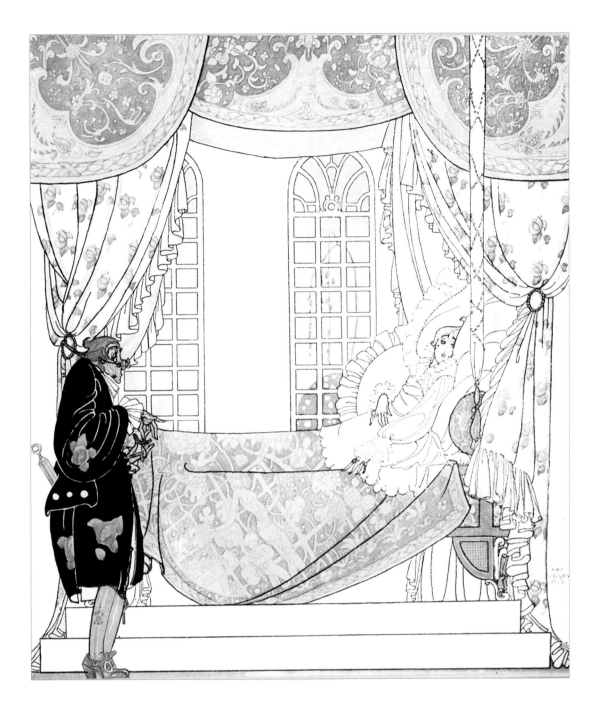

PLATE 27

He had to take to his bed for a week
("Minon-Minette")

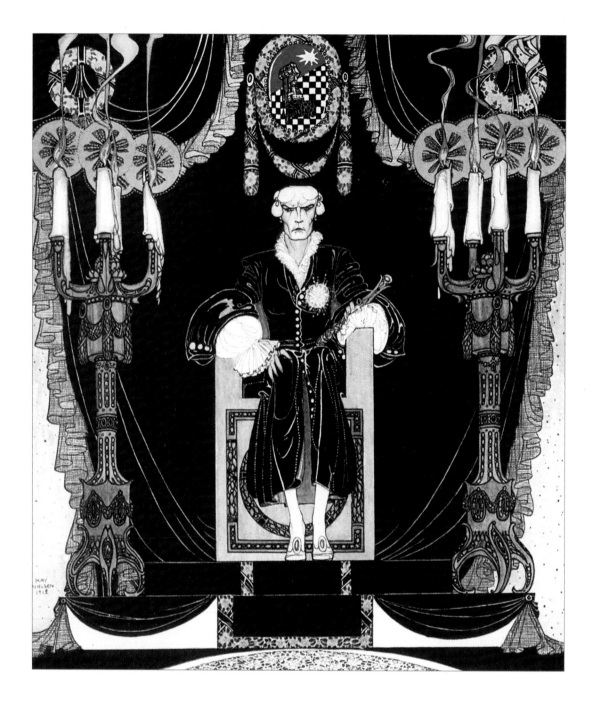

PLATE 28

And there on a throne all covered with black
sat the Iron King
("Minon-Minette")

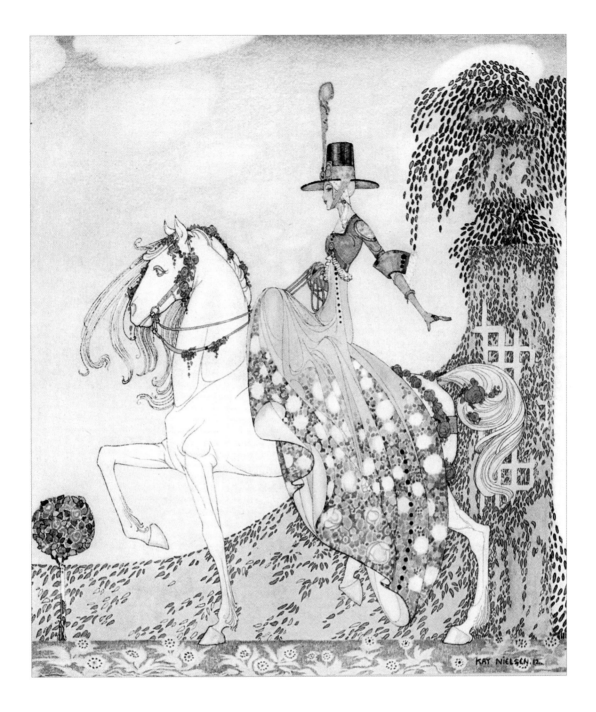

PLATE 29

Princess Minon-Minette rides out in the world
to find Prince Souci
("Minon-Minette")

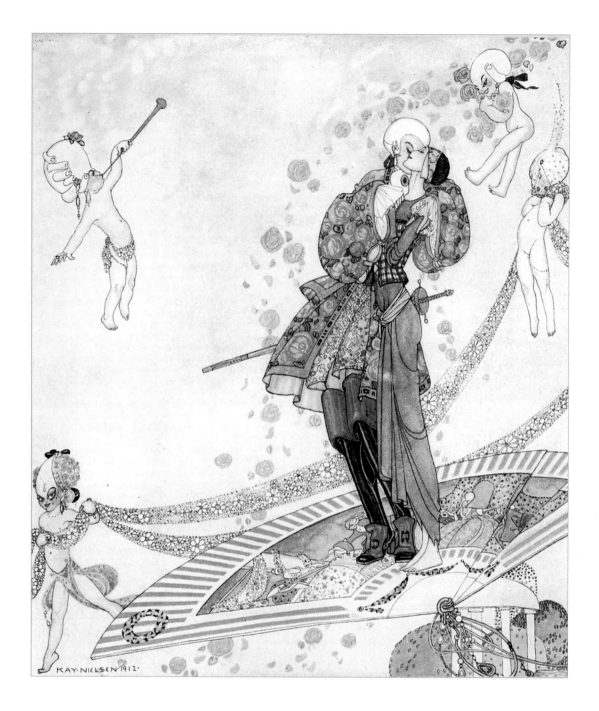

PLATE 30

Prince Souci and Princess Minon-Minette on the fan
("Minon-Minette")

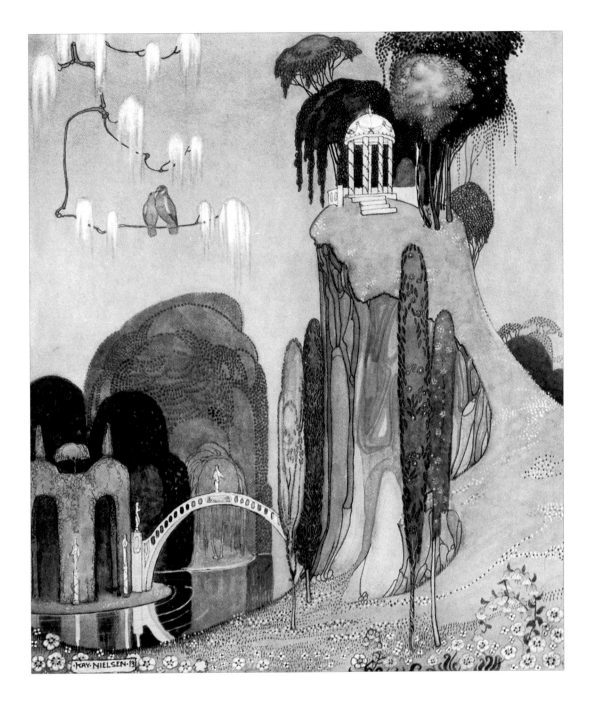

PLATE 31

"List, ah, list to the zephyr in the grove!
Where beneath the happy boughs
Flora builds her summerhouse:
Whist! Ah, whist! While the cushat tells his love."
("Felicia, or The Pot of Pinks")

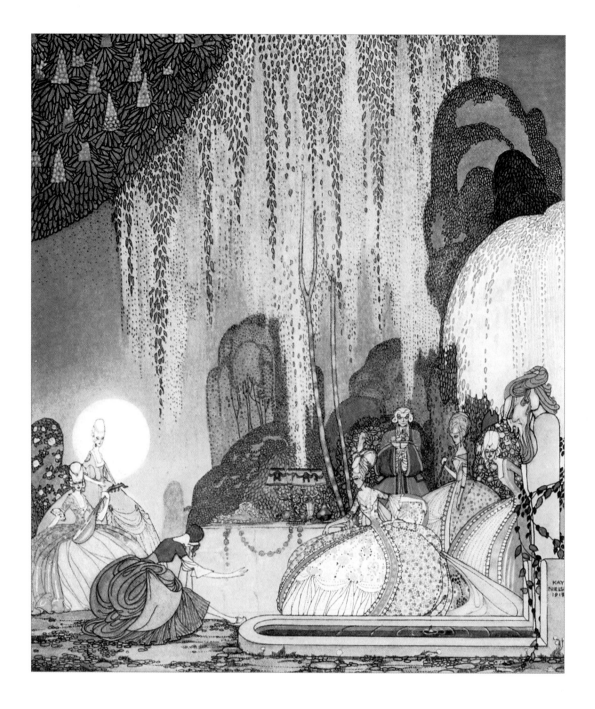

PLATE 32

*Felicia thereupon stepped forth, and terrified though
she was, saluted the Queen respectfully:
with so graceful a curtsey*
("Felicia, or The Pot of Pinks")

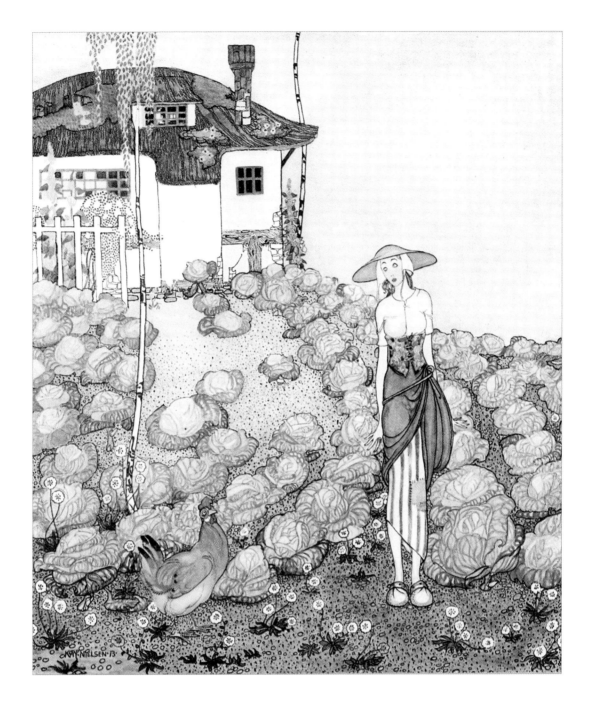

PLATE 33

Felicia listening to the hen's story
("Felicia, or The Pot of Pinks")

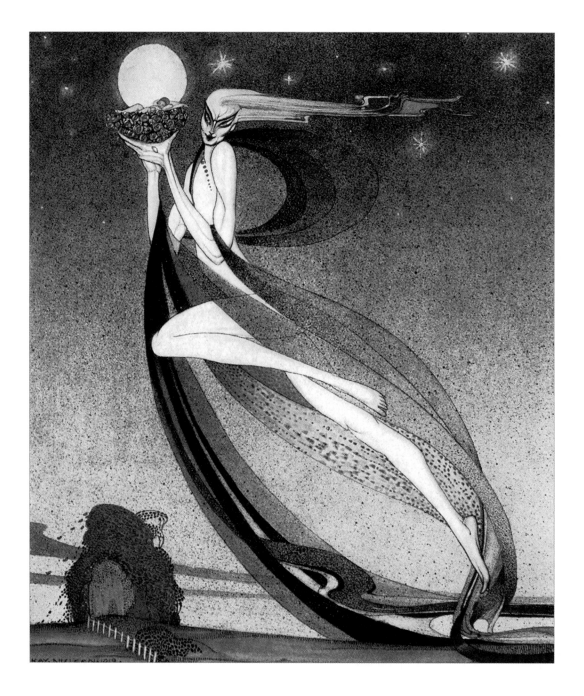

PLATE 34

*"This good Fairy placed her own baby in a cradle of roses
and gave command to the zephyrs to carry him to the tower"*
("Felicia, or The Pot of Pinks")

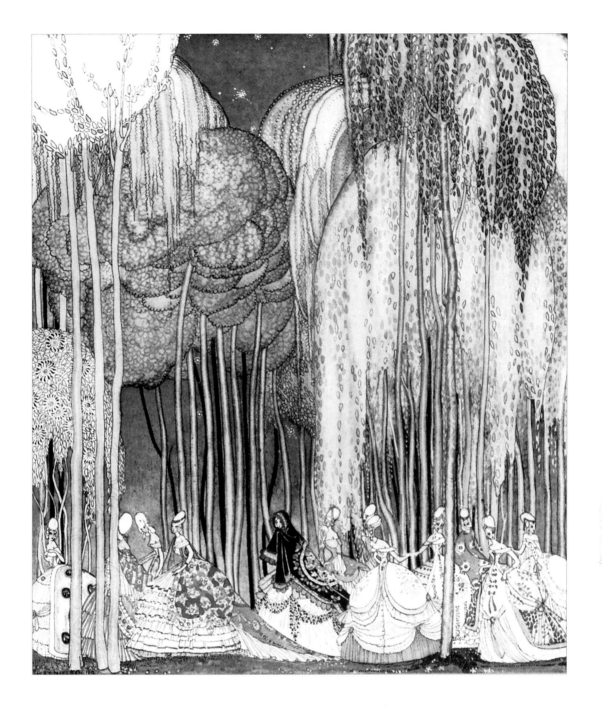

PLATE 35

The Princesses on the way to the dance
("The Twelve Dancing Princesses")

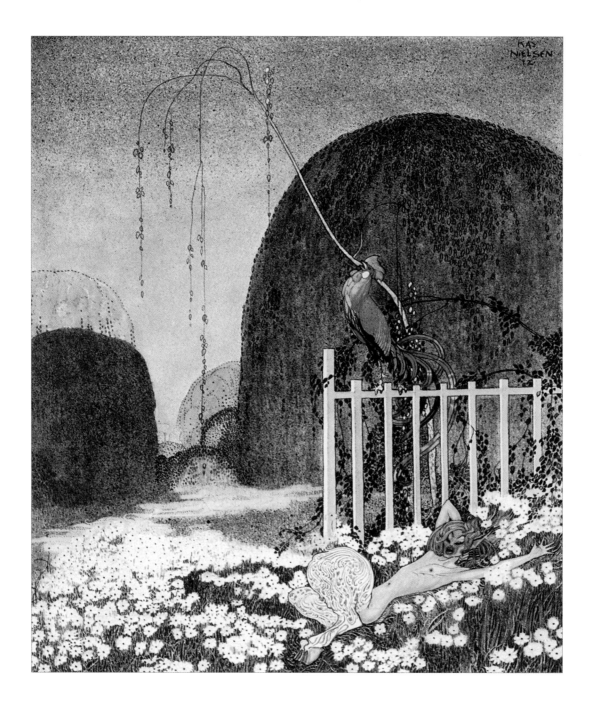

PLATE 36

When the cock crowed
("The Twelve Dancing Princesses")

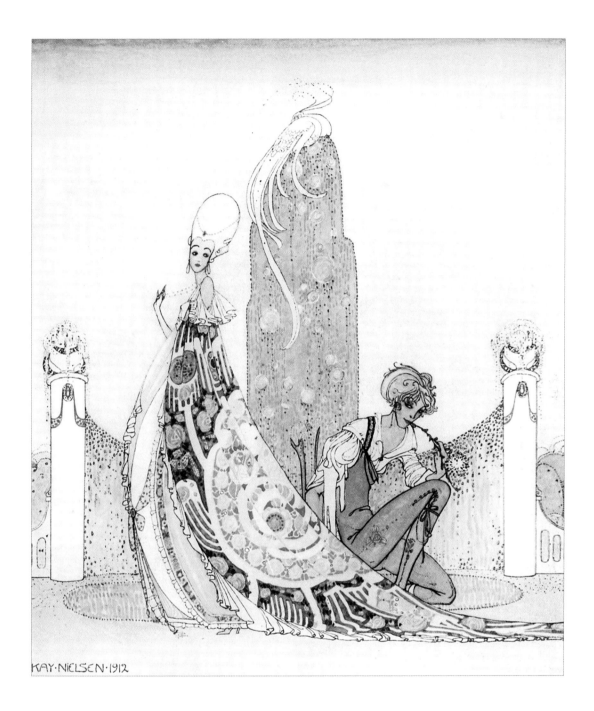

PLATE 37

She stopped as if to speak to him; then, altering her mind,
went on her way
("The Twelve Dancing Princesses")

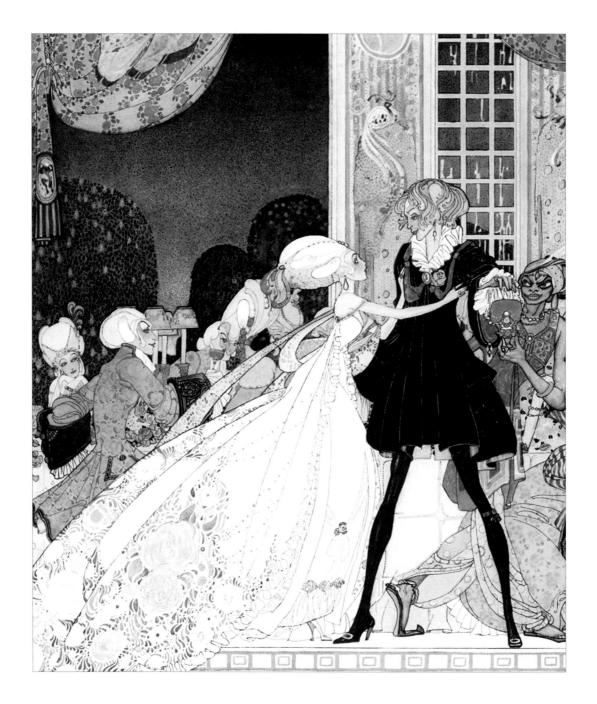

PLATE 38

"Don't drink!" cried out the little Princess, springing to her feet;
"I would rather marry a gardener!"
("The Twelve Dancing Princesses")

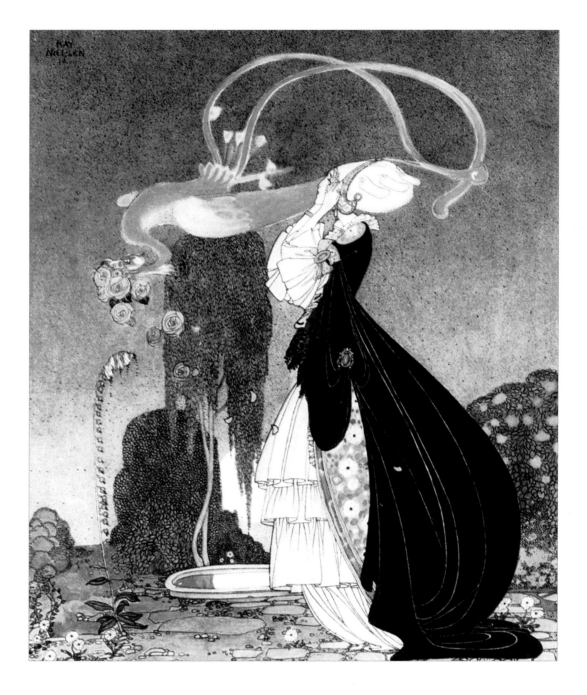

PLATE 39

"I have had such a terrible dream," she declared.
"....a pretty bird swooped down, snatched it from my hands
and flew away with it"
("Rosanie or The Inconstant Prince")

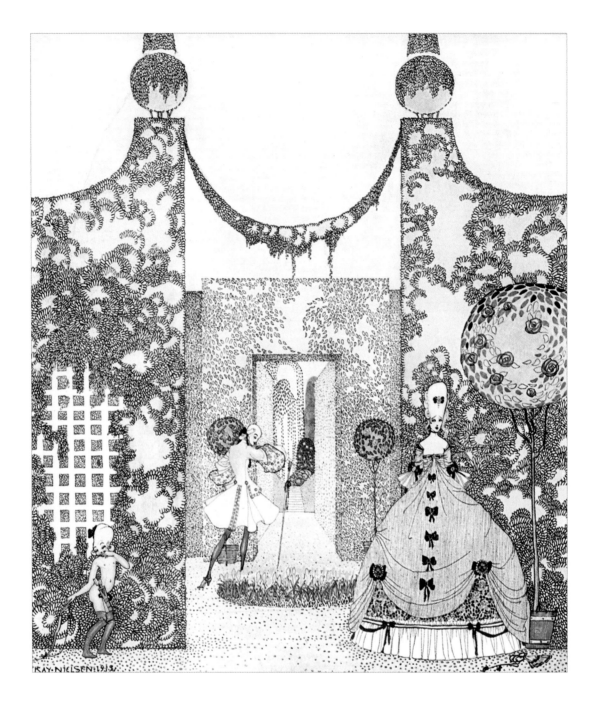

PLATE 40

A look—a kiss—and he was gone
("Rosanie or The Inconstant Prince")

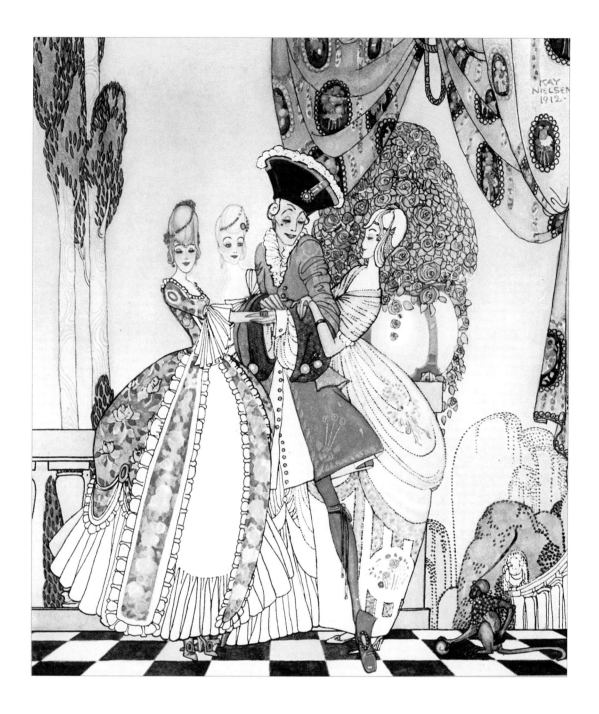

PLATE 41

Each was delicious in her different way;
and, for the life of him,
he could not make up his mind
("Rosanie or The Inconstant Prince")

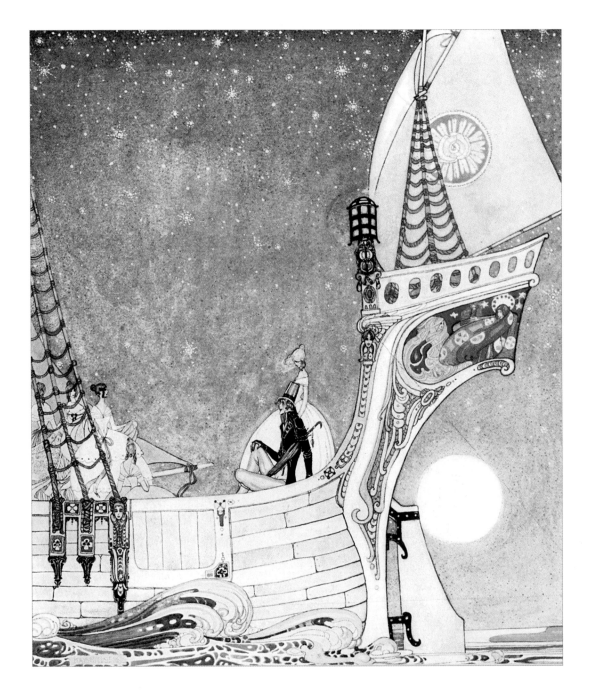

PLATE 42

The ship headed about and sped over the depths of the sea
("The Man Who Never Laughed")

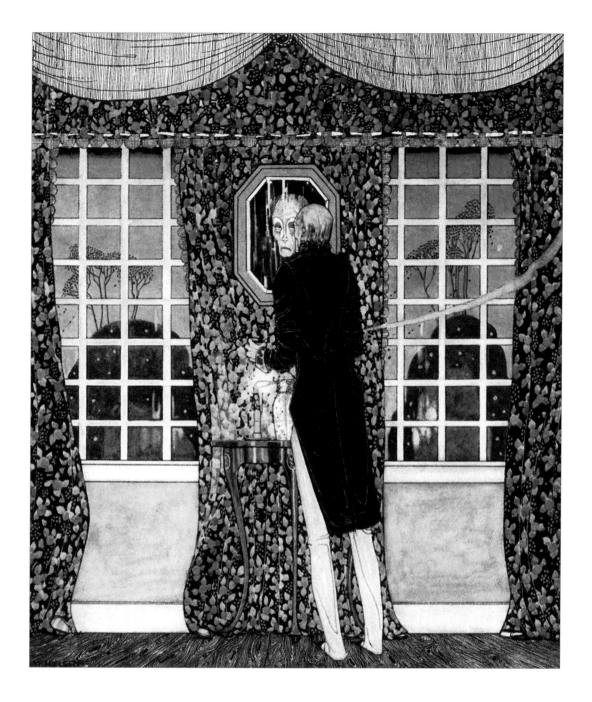

PLATE 43

And the mirror told him that his were indeed
the withered face and form
("The Man Who Never Laughed")

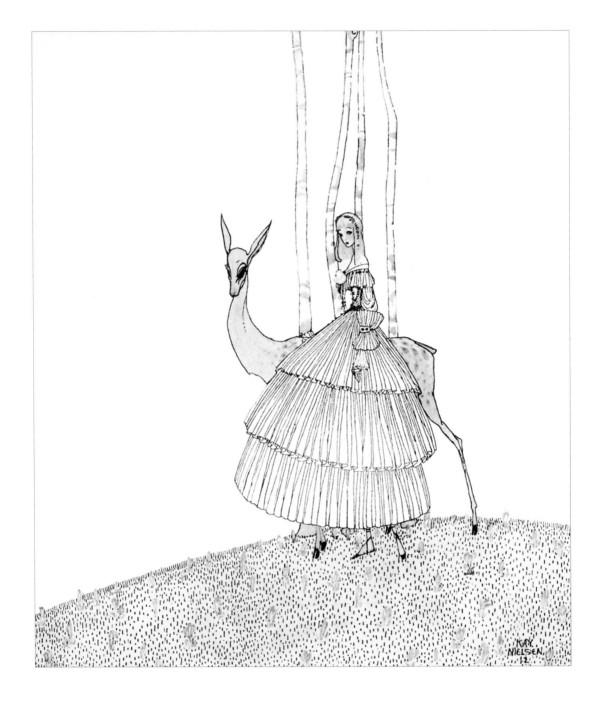

PLATE 44

*"It's about the Princess, my daughter. She has not smiled
for a whole year"*
("John and the Ghosts")

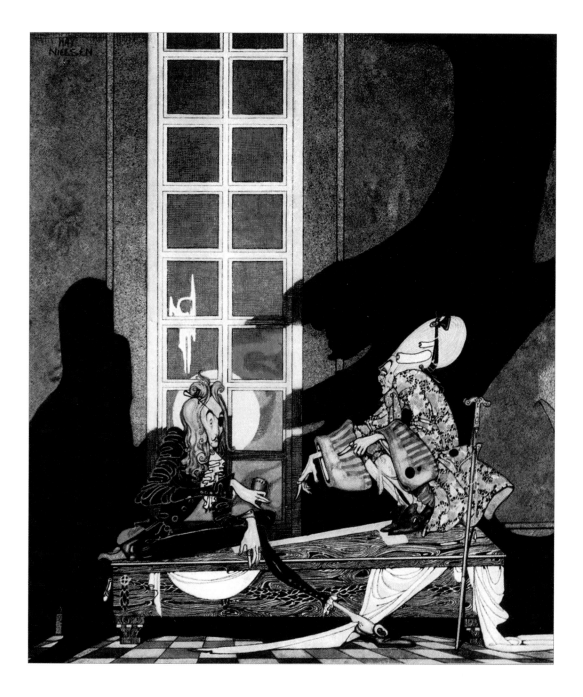

PLATE 45

"Your soul!—My soul!" they kept saying in hollow tones,
according as they won or lost
("John and the Ghosts")

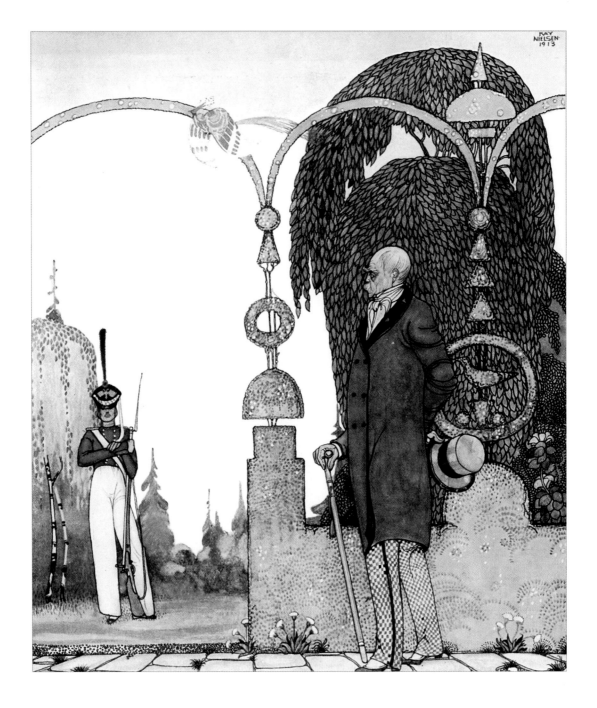

PLATE 46

Bismarck discovering the soldier
("The Czarina's Violet")

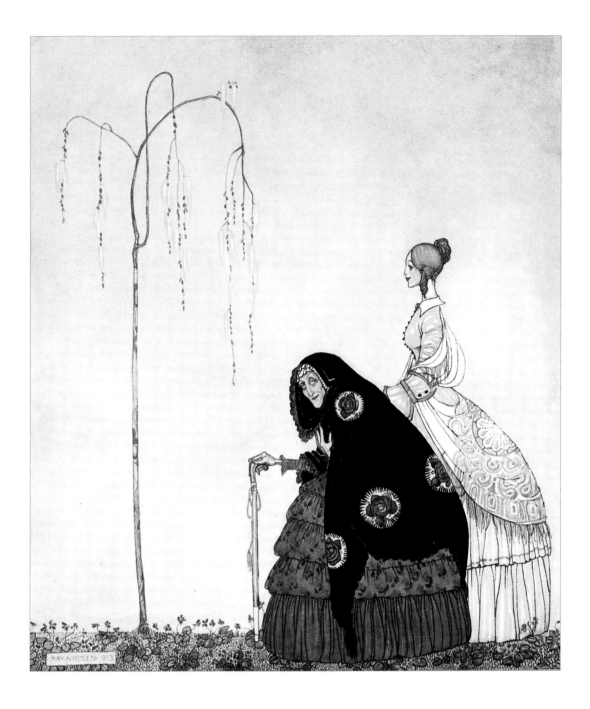

PLATE 47

The old woman who knew the story
("The Czarina's Violet")

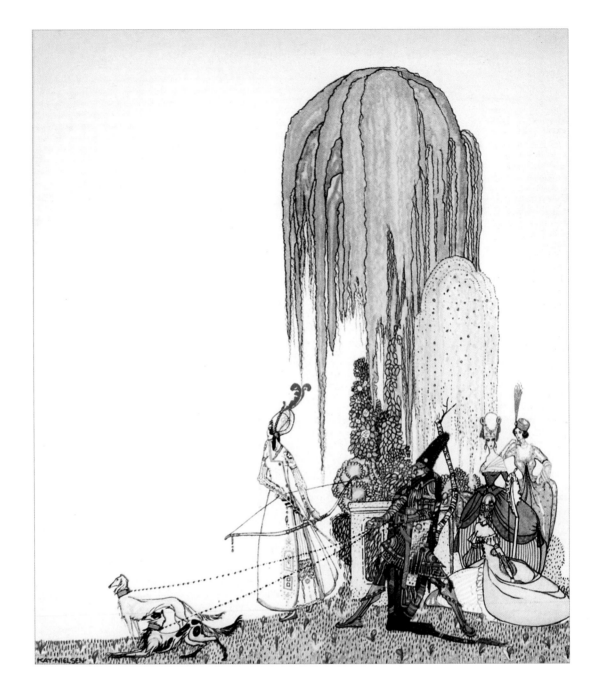

PLATE 48

Czarina's Archery
("The Czarina's Violet")

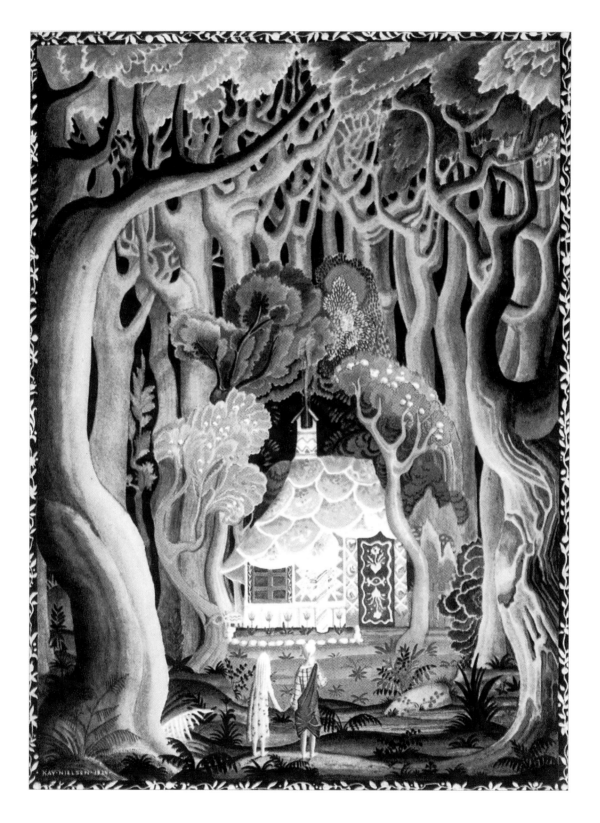

PLATE 49

They saw that the cottage was made of bread and cakes
("Hansel and Gretel")

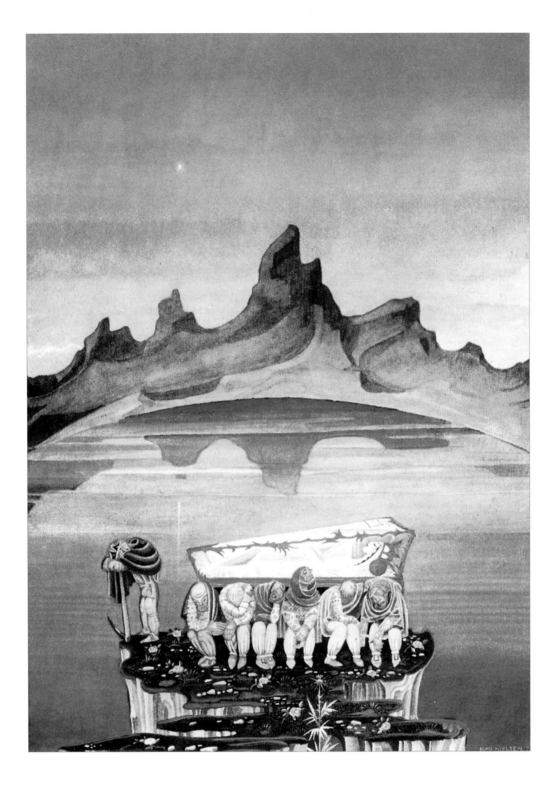

PLATE 50

They wrote her name upon it, in golden letters,
and that she was a king's daughter
("Snowdrop")

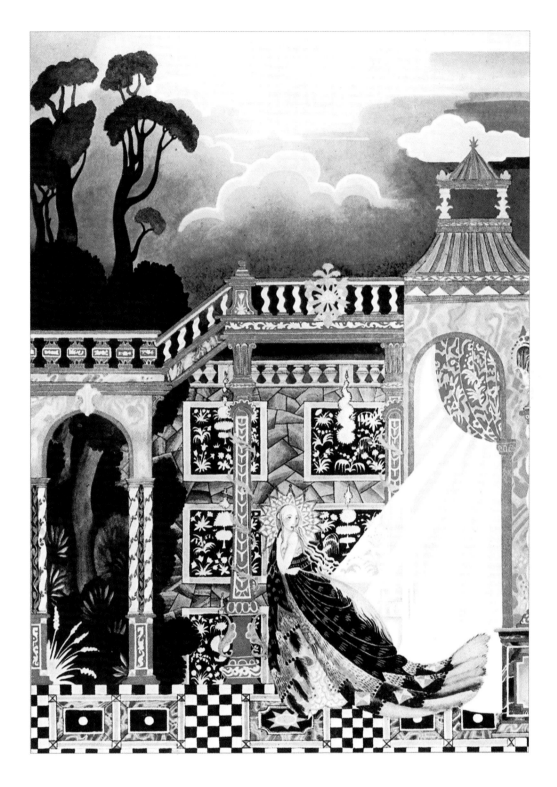

PLATE 51

She managed to slip out so slyly that the King
did not see where she was gone
("Catskin")

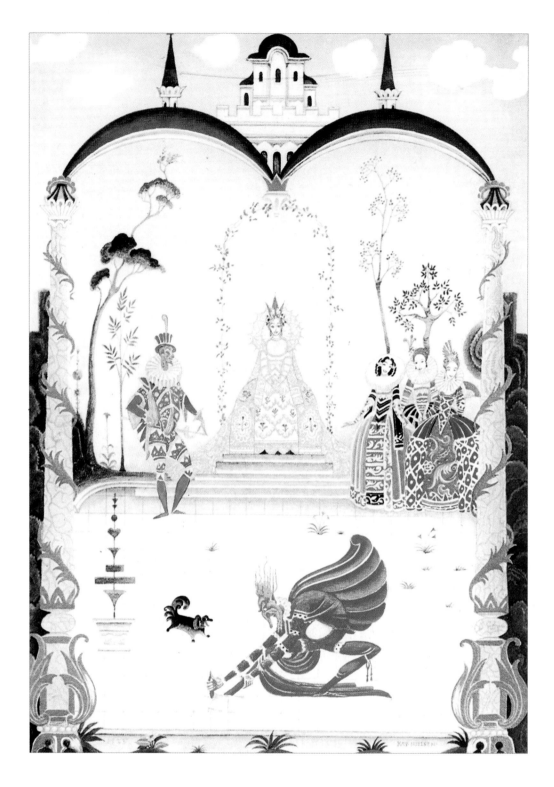

PLATE 52

The little man dashed his right foot so deep into the floor
that he was forced to lay hold of it
with both hands to pull it out
("Rumpelstiltskin")

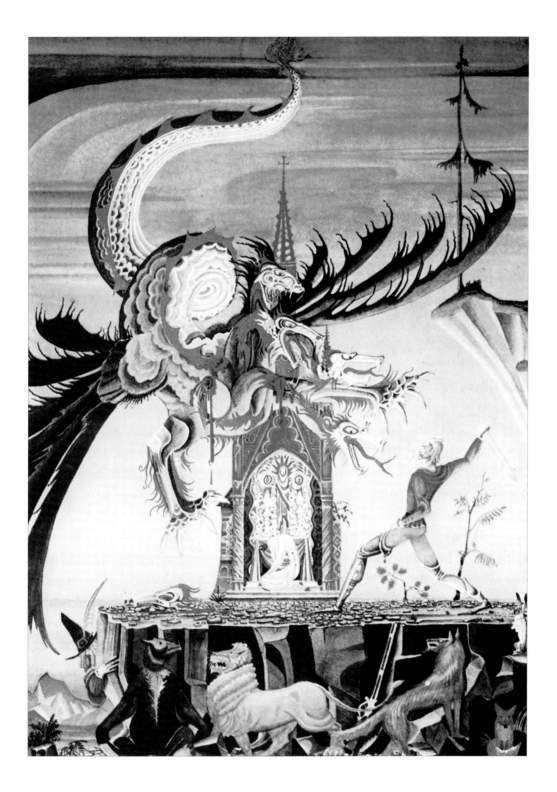

PLATE 53

Then the dragon made a dart at the hunter,
but he swung his sword round and cut off
three of the beast's heads
("The Two Brothers")

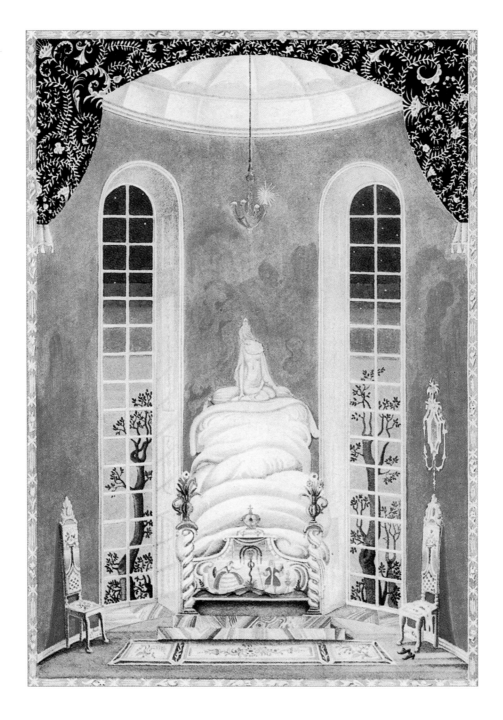

PLATE 54

"Oh, very badly indeed," she replied. "I have scarcely
closed my eyes the whole night through.
I do not know what was in my bed"
("The Real Princess")

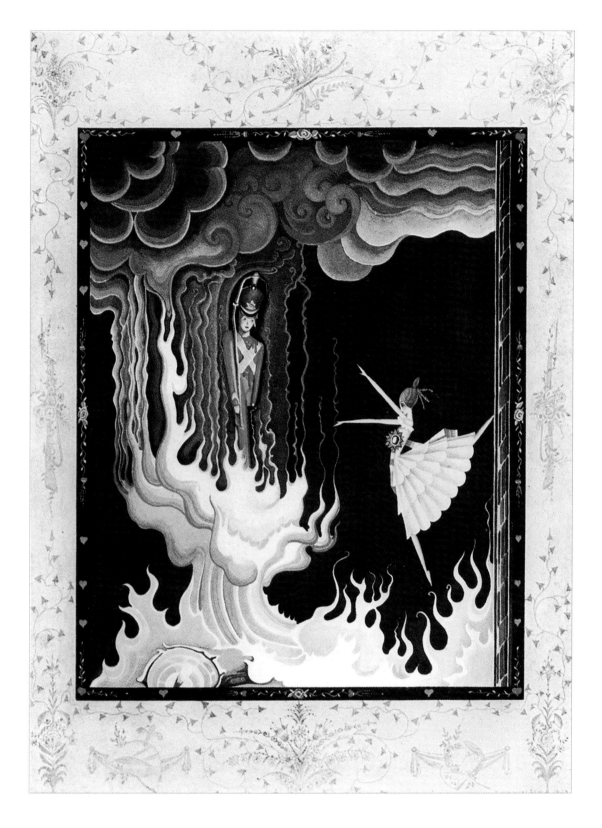

PLATE 55

The draught of air caught the dancer, and she flew like a sylph
just into the stove to the tin soldier
("The Hardy Tin Soldier")

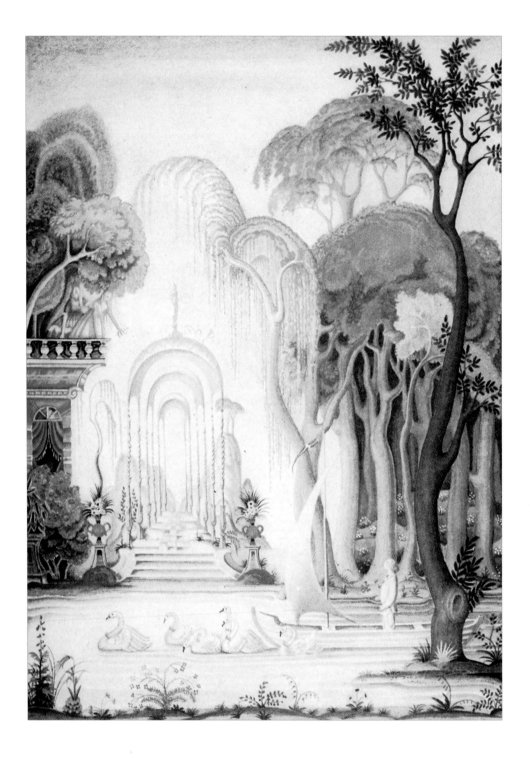

PLATE 56

That was a pleasure voyage. Sometimes the forest was thick
and dark, sometimes like a glorious garden
full of sunlight and flowers
("Ole Luk-Oie")

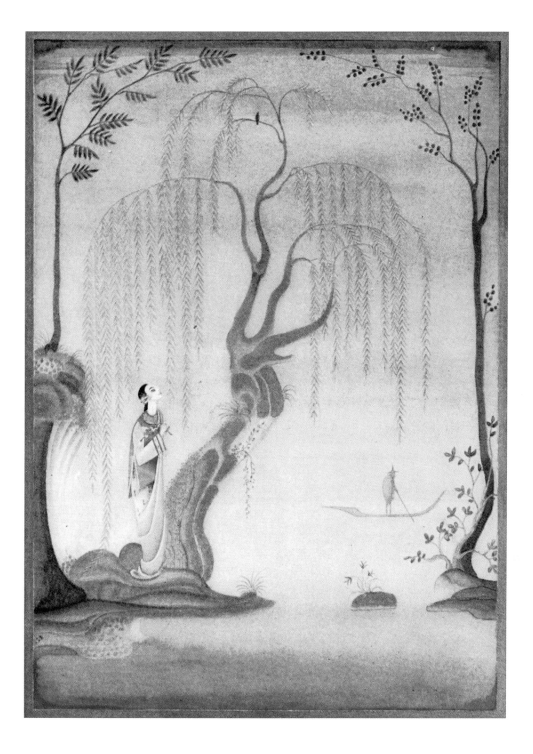

PLATE 57

And when I get back and am tired, and rest in the wood,
then I hear the Nightingale sing
("The Nightingale")

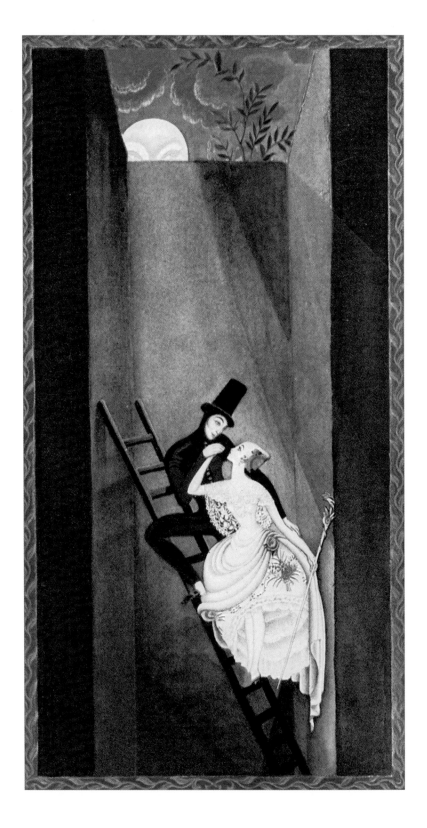

PLATE 58

"We'll mount so high that they can't catch us,
and quite at the top there's a hole that leads out
into the wide world"
("The Shepherdess and the Chimney-Sweeper")